PRELIMINARY CATALOGI

OF THE

REBECCA DARLINGTON ST
COLLECTION OF GREEK AND
ITALIAN VASES

MEMORIAL HALL, YALE UNIVERSITY

By

P. V. C. BAUR

*With the assistance of Dr. Arndt's Inventory of the
Collection by Dr. Georg Lippold*

YALE UNIVERSITY
NEW HAVEN
MDCCCGXIV

PREFATORY NOTE

At a meeting of the Prudential Committee of the Corporation of Yale University on April 5, 1913, a pledge of twenty-five thousand dollars was reported from "an anonymous friend" to enable the University to acquire and care for a notable collection of Greek and Etruscan vases made by Dr. Paul Arndt, of Munich. At the same time another donor, whose name by request has never been made public, promised five thousand dollars, which was used to defray the expense of suitably housing the collection in the President's Reception Room, Memorial Hall.

On May 19, 1913, the Corporation voted, "to name the important collection of Greek and Etruscan vases to be installed in the President's Reception Room, Memorial Hall, 'The Rebecca Darlington Stoddard Collection' in honor of the donor, who has now consented that announcement should be made of her gift which is of such value both to the City and to the University."

The Rebecca Darlington Stoddard Collection was first opened to the public on January 25, 1914. Mrs. Stoddard died on December 13, 1913, and therefore never saw the vases. These have, however, as she hoped and planned, proved of great interest to many residents of the City of New Haven and to numerous visitors, as well as to members of the University.

The nucleus of the collection was obtained by Dr. Arndt at an auction sale in Paris of some vases which had for many years been in the possession of a family there. As opportunity presented itself the gaps were filled by purchases made by Dr. Arndt with a view to rendering the collection of the greatest historical value to university students. The success of his efforts has been attested by the increasing interest shown by many scholars in the vases now exhibited in Memorial Hall.

P. V. C. BAUR.

CONTENTS

		NUMBER
I.	Prehistoric Egyptian	1–2
II.	Prehistoric from Asia Minor	3–4
III.	Cypriote	5–31
	(a) Base-ring ware	5
	(b) White slip ware	6
	(c) Painted white ware	7–8
	(d) Mycenæan period	9
	(e) Græco-Phœnician period	10–22
	(f) Fabric of Amathus	23–24
	(g) Various styles	25–31
IV.	Mycenæan (Late Minoan III)	32–51
V.	Geometric	52–61
	(a) Not Attic	52–53
	(b) Attic Dipylon	54–61
VI.	Græco-Egyptian Faience	62–63
VII.	Vases not painted, design impressed	64–66
VIII.	Rhodian	67–70
IX.	Laconian (Cyrenaic)	71
X.	Proto-Corinthian	72–78
XI.	Corinthian	79–104
XII.	Attic black-figured	105–128
	(a) Vurva style	105–106
	(b) Developed black-figured style	107–128
XIII.	Attic red-figured	129–172
XIV.	Vases in the form of various objects	173–179
XV.	Bœotian	180–196
	(a) Orientalizing	180–183
	(b) Early black-figured	184–188
	(c) Cabirian	189
	(d) Late black-figured	190–195
	(e) Red-figured	196
XVI.	"Megarian" bowls	197–210
XVII.	Late Greek (Miscellaneous)	211–217

		NUMBER
XVIII.	Early Italic	218–222
XIX.	Bucchero	223–228
XX.	Italo-Corinthian	229–231
XXI.	Italo-Ionic	232–240
XXII.	Early Apulian	241–258
XXIII.	Apulian red-figured	259–275
	(a) Painted design	259-262
	(b) Ground-colored figures . . .	263–275
XXIV.	So-called Gnathian ware	276–309
XXV.	Apulian with yellow slip	310–317
XXVI.	Canosa ware	318–320
XXVII.	Miscellaneous Apulian	321–323
XXVIII.	Lucanian red-figured	324–326
XXIX.	Calenian	327–330
XXX.	Campanian	331–335
XXXI.	Italian red-figured (Miscellaneous) .	336–347
XXXII.	Late Etruscan	348
XXXIII.	Italian and Sicilian (Hellenistic) .	349–357
XXXIV.	Gutti with black glaze and reliefs .	358–374
XXXV.	Black-glazed ware (Greek or Italian under Greek influence) . . .	375–457
XXXVI.	Black-glazed Italian	458–472
XXXVII.	Stamped black-glazed	473–488
	(a) Greek or Italian under Greek influence	473–482
	(b) Italian	483–488
XXXVIII.	Black-glazed Hellenistic	489–502
XXXIX.	Black-glazed Hellenistic with applied white paint	503–509
XL.	Terra Sigillata	510–552
	(a) Roman-African, not genuine sigillata	510–511
	(b) Miscellaneous, not genuine sigillata	512–515
	(c) Greek red ware	516–519

NUMBER

(d) Italian 520–531

(e) Roman Gaul (Germany) . . 532–550

(f) Fragments of forms and modern

casts 551–552

XLI. Roman 553–585

XLII. Roman Provincial 586–591

XLIII. Egyptian (Roman and early Chris-

tian) 592–595

XLIV. Lamps 596–676

(a) Greek, turned on potter's wheel . 596–599

A: Open on top, handle, one

nozzle 596–597

B: Open on top, no handle, hole

in middle for support . . 598–599

(b) Italian, turned on potter's wheel 600–601

C: Similar to A, but high foot . 600

D: Small opening, ring-shaped

handle 601

(c) Roman, made from a mould . . 602–673

E: Rectangular nozzle, one

handle 602

F: Angular volute-nozzle . . 603–610

G: Circular volute-nozzle . . 611–629

H: Similar nozzle with volute

extending to the shoulder . 630–631

I: Circular nozzle 632–640

J: Circular nozzle with two

bands in relief on shoulder . 641–643

K: Heart-shaped nozzle and

decorated shoulder . . . 644

L: With open spout 645–647

M: Christian 648–654

N: With open receptacle and

long open nozzle (early

Mediæval) 655

vi CONTENTS

 NUMBER
 O: Imitating various objects . 656–661
 P: Miscellaneous 662–673
 Q: Mould and modern cast . . 674
 R: Lanterns 675–676

 PAGE
Index 55

REBECCA DARLINGTON STODDARD COLLECTION OF GREEK AND ITALIAN VASES

I. Prehistoric Egyptian (about 5000 B. C.)

1. Cup in shape of ostrich-egg. Brown clay, reddish-brown pigment. On each side row-boat with two cabins; mast and spread sail below. Hand-made and sun-baked. Perforated projections for a string.
2. Same shape. Yellow clay, reddish-brown pigment. Imitation of basketry.

II. Prehistoric from Asia Minor (about 3000 B. C.)

3. Hemispherical bowl with one handle. Brown clay. Hand-made but burned near open fire.
4. Similar, but burned black inside and on the rim outside over open fire. Hand-polished surface. On the rim a perforated projection for a string.

III. Cypriote

(a) *Base-ring ware*

5. Pitcher. Reddish-brown clay, leather-colored surface. Between 2000 and 1500 B. C.

(b) *White slip ware*

6. Hemispherical bowl with one handle. Geometric decoration in black pigment occasionally turning to red by action of fire. Imitation of gourd. 2000-1500 B. C.

(c) *Painted white ware*

7. Flask with two tube-like spouts. Reddish clay, red pigment. Linear designs. Covered with perforated projections for attachment of strings. Hand-made. 2000-1500 B. C.

8. Oblong flask of greenish-white clay. Dark brown pigment. Linear designs, perforated projections. Imitation of leather pouch. Hand-made. 2000-1500 B. C.

(d) *Mycenæan period*

9. Ring-shaped vase. Light brown clay, partly red, red pigment. Linear design. Hand-made. About 1500 B. C.

(e) *Græco-Phœnician period* (800-400 B. C.)

10. Aryballus of white clay. Black pigment. Concentric circles.

11. Aryballus of white clay. Purple and brown pigment. Concentric circles.

12. Cylix with two handles. From Carpasia. Reddish clay, red slip and black paint. Concentric circles.

13. Saucer. Red clay, black paint. Inside and outside concentric circles.

14. Bowl with two handles. Red clay, black paint. Concentric circles.

15. Aryballus. Red clay, black paint. Plastic ring on neck. Painted rings encircle the body, above these are concentric circles.

16. Similar.

17. Globular jug. Red clay. Rings painted in black encircle the body, also concentric circles.

18. Similar.

19. Jug. Brown paint, burned red and black in the firing. The concentric circles are occasionally touched up with white paint.

20. Pitcher of red clay highly polished. Belongs to same group as no. 19.
21. Small pitcher. Concentric circles around the body.
22. Amphora. Decorated with rings and concentric circles.

(f) *Fabric of Amathus* (about 800 B. C.)

23. Amphora of white clay. Decorated with linear patterns in purple and dark brown colors.
24. Amphora of white clay. On either side a primitive bird in a panel surrounded by reticulated design.

(g) *Various styles*

25. Pitcher with a spout modelled in the form of a woman holding a jug. Black and white circles around the body. First half of fifth century B. C.
26. Flask with two handles. White clay decorated with reddish-brown concentric circles.
27. Deep saucer of coarse clay and yellowish-white slip. Decorated with concentric circles in black and red color. On the rim two holes for suspension.
28. Saucer with white slip and decorated like no. 27. Pierced with nine triangular-shaped holes.
29. Bowl with two handles. Coarse white clay. Similar to no. 27 in style.
30. Lecythus with red slip.
31. Barrel-shaped vase with two handles. Reddish-brown clay. Body fluted vertically with concentric circles. Found in Egypt. Cypriote (?) fabric.

IV. MYCENÆAN

Late Minoan III (1350-1100 B. C.)

Various centers of production

32. Large stirrup-vase. Coarse brown clay decorated with dull dark brown color.

33. Small stirrup-vase. Red lustrous varnish painting. On the shoulder bird and fish.

34. Small stirrup-vase found near Patras. Yellow clay, reddish-brown lustrous varnish.

35. Small stirrup-vase. Greenish clay. The color has almost entirely flaked off.

36. Small stirrup-vase found near Patras. Clay and color like no. 34.

37. Pitcher. Yellow clay, red lustrous varnish for the linear decoration.

38. Large vase with three handles set vertically. Found on the island of Rhodes. Brown clay. The varnish varies from brownish-black to red, because it was applied in a thin coat. On the shoulder conventionalized tendrils and flower pattern between the handles.

39. Similar shape, also from Rhodes. Spiral decoration on shoulder.

40. Similar shape, but smaller. The handles are set horizontally. Found near Patras. Yellow clay and reddish-brown lustrous varnish. Debased lily pattern on shoulder.

41. Similar shape, but very small. Found near Patras. Brown clay. On the shoulder in lustrous brown color reticulated pattern.

42. Bowl-shaped vase with three handles set horizontally. Found near Patras. Yellowish-brown clay, dark brown lustrous varnish for the decoration. Between the handles arch-shaped designs.

43. Similar shape, but very small. Reddish clay, reddish-brown lustrous varnish for decoration.

44. Mug of reddish-yellow clay decorated with linear designs in red lustrous varnish.

45. Vase with two handles and spout, the bottom slightly convex. Yellow clay decorated with red lustrous varnish. On the shoulder conventionalized lilies.

46. Bowl with two handles similar in shape to no 42. Found near Patras. Brownish clay decorated with linear designs in brown varnish.

47. Amphora of light brown clay decorated with linear designs in dark brown paint. Very late Mycenæan under influence of Geometric Style.

48. Similar shape and material. On the shoulder concentric circles drawn with a pair of compasses.

49. Vase shaped like a ring with spout and handle, found near Patras. Brownish clay decorated with linear designs in lustrous brown varnish.

50. Crater from Rhodes. Brownish-yellow clay decorated with linear designs in reddish-brown varnish. Between the handles vertical bands of herring-bone pattern.

51. Vase in the form of an ox. Reddish-brown clay decorated with dark brown varnish. A wreath is painted around the neck of the animal.

V. GEOMETRIC

(a) *Not Attic* (1100-900 B. C.)

52. Amphora with horizontal handles on shoulder. Reddish clay covered with white slip of fine clay on which the designs are painted in dark brown varnish. The symmetry of form somewhat spoiled in the firing. Unknown fabric.

53. Globular pitcher with trefoil lip. Brown clay decorated with dark brown varnish. On shoulder and body concentric circles, on neck lozenge pattern. Cypriote (?) influence.

(b) *Attic Dipylon* (1000-700 B. C.)

54. Double pitcher, hand-made; between the necks a man primitively modelled. Brown clay, black varnish.

55. Pitcher with high handle and trefoil lip. Reddish

clay, dark brown varnish. Perhaps early Proto-
Corinthian.

56. Pitcher with high handle. Reddish clay decorated with
dark brown varnish. On the neck three panels; in
the central panel circles connected by tangents sur-
rounded by a wreath, in the other panels a bird
(goose?).

57. Saucer with two bow-shaped handles. Reddish clay,
light brown painting. On the bottom outside a
flower with four petals.

58. Deep bowl with perforated foot and two horizontal
bow-shaped handles. Yellowish-brown clay, black
painting. Panels with swastika on shoulder.

59. Similar form. Light brown clay, dark brown painting.
On the body between the handles a row of birds to
right; above, a meander pattern, interrupted above
the handles by horse and star.

60. Similar form, but very high foot and lid. Light brown
clay, dark brown painting. Between the rays on
the lid swastikas.

61. Vase in form of pomegranate. Brown clay, black paint-
ing. Around the body double meander.

VI. GRÆCO-EGYPTIAN FAIENCE

62. Vase in form of hedgehog. White clay. The enamel
has almost entirely disappeared.

63. Similar form and material, but the blue enamel is
better preserved. In front of the opening head and
arms of a bearded man. Similar examples from
Olbia.

VII. VASES NOT PAINTED, DESIGN IMPRESSED

64. Pitcher of form similar to no. 55. Hand-made.
Brownish-yellow clay. The design consists of wavy
incised lines. Unknown fabric.

65. Similar.
66. Jug with globular body.

VIII. Rhodian

67. Large flask with one handle, from Rhodes. Brown clay, reddish-brown varnish shading into dark brown. Concentric rings like Cypriote flask no. 26, also wavy lines.
68. Bowl with two handles. Brown clay, dark brown varnish. Geometric designs, standing bird. About 900 B. C.
69. Alabastrum in form of helmeted head from Syme near Rhodes. Clay burned grey, black paint, eyes red. Sixth century B. C.
70. Deep bowl with two upright horizontal handles. Lid lost. Brown clay, dark brown varnish painting. Two grotesque heads of a woman in outline drawing; each wears hood, ear-rings and necklace. To right and left primitive birds. Fourth century B. C.

IX. Laconian

71. Cylix, foot missing. Brown clay covered with white slip. Lustrous varnish painting. So-called fourth style. Another center of production of this ware was at Cyrene. Similar examples from Sardis.

X. Proto-Corinthian (900-700 B. C.)

72. Scyphus. Light grey clay, brownish-red varnish. Horizontal herring-bone pattern between vertical lines on shoulder, circles around the lip, otherwise entirely varnished.
73. Lecythus bought at Naples. Yellow clay, reddish-brown paint. Linear designs, rays on the shoulder.

74. Lecythus. Similar material. Linear designs.
75. Lecythus. Similar material. Hare and three dogs to right.
76. Lecythus. Reddish-yellow clay, black and red varnish. Three dogs and bird to left.
77. Lecythus. Yellow clay, dark brown varnish. On the body three dogs to left, some details incised.
78. Lecythus. Reddish clay, red painting. On the shoulder two dogs to left. These and the following lecythi, alabastra and aryballi were used for precious unguents and perfumery manufactured at Corinth.

XI. CORINTHIAN (seventh century B. C.)

79. Alabastrum. Yellow clay, dark brown and black varnish painting. On the body a frieze of quadrupeds difficult to identify, a goat, a deer and a bird to right.
80. Alabastrum. Similar material and varnish, but also incisions. On the body front half of bull to left and of a lion to right. Rosettes fill the field.
81. Alabastrum found at Thebes. Yellow clay, black varnish and occasionally superimposed red paint. Details of rosettes, etc., are incised.
82. Alabastrum of unusually large size. Yellow clay, black varnish, superimposed red and yellowish-white paint, also incisions, to mark details. On the body two lions confronted, their tails intertwined. Between them a standing eagle (?).
83. Aryballus without base-ring. Yellow clay, brownish-black varnish, superimposed red color here and there, yellowish-white incisions. Linear decoration.
84. Aryballus. Yellowish-brown clay, lustrous brown varnish and dull red paint occasionally superimposed. Rosette and palmettes on the body.
85. Aryballus. Yellow clay, dark brown varnish painting. Decoration like no. 84 but no red paint.

86. Aryballus. Yellow clay, the varnish varies from reddish-brown to black. Rosette of eight buds alternately red and the color of the clay.

87. Aryballus. Yellow clay, dark brown varnish, superimposed red paint and incisions. Male and female bust confronted, rosettes in the field.

88. Aryballus. Yellow clay, brownish-black varnish, incisions. On the spherical body nine warriors to right, primitively drawn. The field covered with dots.

89. Aryballus with ring-shaped foot. Purchased on the island of Syra. Yellow clay, dark brown varnish, superimposed red paint, incisions. On the body palmette between sirens; behind is a swan. Rosettes fill the field.

90. Aryballus with ring-shaped foot like no. 89. Linear design.

91. Scyphus. Greenish-yellow clay, the paint varies from reddish-brown to black. Linear design.

92. Ring-shaped ointment-jug. Yellow clay, dark brown varnish, superimposed red paint, incisions. On the outside a human face sketched in outline, then two horses to left giving the effect of embroidery.

93. Ointment-jug in form of siren. Brownish-yellow clay, dark brown varnish, red paint.

94. Pyxis (cylindrical box with cover used by women for the toilet) with three feet. Brownish-yellow clay. Black and brown varnish and red paint. Linear design. Late Corinthian.

95. Pyxis with flat bottom. Yellow clay, dark brown paint burned reddish-brown on one side in the firing. Red paint added. Late Corinthian.

96. Lid of a pyxis. Greenish-yellow clay, similar colors. Linear design. Late Corinthian.

97. Spherical bowl with lid and two upright handles. Yellow clay, dark brown varnish and red paint. Linear design.

98. Lid of a pyxis. Greenish-yellow clay, brown varnish and red paint. Linear design.

99. Lid of a pyxis. Greenish clay, black varnish and red paint. Palmette and lotus pattern.

100. Lamp (incorrectly called Kothon) with one handle. Greenish clay, dark brown varnish and red paint. Linear design.

101. Similar.

102. Bowl with high foot and two upright handles. Yellow clay, dark brown varnish and superimposed red paint. Details incised. On foot six goats. On body two panthers confronted, the tail of the panther on the right is intertwined with the tail of another panther to right, then goat to left, panther to right and finally goat to left. Rosettes and blots fill the field.

108. Cylix of reddish clay and black glaze varnish painting with superimposed red pigment. Details incised. Outside on the body a row of six dancers; of the three on the front side one is bearded, the three on the other side are beardless. Their garments are red. The central figure holds a rhytum (drinking-horn). Below the handles palmette and lotus ornament. Uncertain fabric, sixth century B. C.

104. Lecythus of brown clay and dark brown varnish with superimposed red and white paint. Details incised. On the body a siren. Its face, neck and breast are painted white, its hair red. The outstretched wings are red, white and black. Even the ornaments which fill the field have touches of white paint. Unknown fabric under Corinthian influence.

XII. ATTIC BLACK-FIGURED

(a) *Vurva style* (seventh century B. C.)

105. Amphora. Reddish clay, the varnish varies from red to black. Superimposed red and white, details incised.

Above the foot projecting rays, then a band or zone of animals, an eagle flying to left, a panther and bull to left, a panther to right. Above this a zone consisting of a palmette and lotus design between two sirens, and on the other side a siren with outstretched wings to left between two sphinxes (the one on the right is broken away). In the field rosettes. Careful drawing.

106. Hydria. Reddish clay, black varnish, superimposed red paint, incisions. Above the foot projecting rays spaced somewhat closer together than on no. 105. Above the rays a zone of two panthers confronted, behind each a siren, then two sphinxes confronted. On one side of the shoulder a debased lotus ornament between two sphinxes confronted; on the other side two birds. On the neck a zone of two sphinxes separated by a siren with outstretched wings. Rosettes fill the field. Imitation of embroidery.

(b) *Developed black-figured style* (sixth century B. C.)

107. Amphora. Light brown clay, lustrous black varnish, superimposed white and red paint, incised details. From the foot rays radiate, above this on one side a warrior between a pair of eyes, on the other side a dancing girl with a nebris over her dress between a pair of eyes. Under each handle a standing siren. Careless drawing, second half of sixth century B. C.

108. Hydria. Reddish clay, black varnish, superimposed red, incisions. Rays radiate from the foot. On the zone around the body two standing warriors, confronted, attack a third warrior who has fallen on his knee. On the extreme left a bearded man wearing a himation. Above on the shoulder two nude youths on horseback, confronted, between them a siren with outstretched wings. Middle of sixth century B. C.

109. Pitcher. Clay originally red, now greyish-brown due
to fire. It was probably thrown on the funeral pyre.
Black varnish, applied red and white paint, incisions.
On the body two warriors, evidently Ajax and
Achilles, throwing dice in the presence of Athena
who is calling them to battle. About 500 B. C.

110. Lecythus with oval body. Reddish clay, black lustrous
varnish, applied red paint, incisions. Two youths on
horseback to right.

111. Lecythus. Reddish clay, black varnish, applied red and
white paint, incisions. Foot and lower part of body
black. Above this Heracles walking to right in
chiton and lion's skin, at his side quiver and sword,
in his uplifted right hand a club. His opponent
Cycnus is fully armed. Between them an eagle
flying to left, and on either side a group of two
spectators. On the shoulder a panther and a lion,
between them a palmette and lotus-buds. On the
neck projecting rays. Middle of sixth century B. C.

112. Lecythus from Tarentum. Brown clay, black varnish,
applied red and white paint, incisions. Admetus
(Apollo?) stepping into his chariot drawn by four
wild beasts, lion, panther, boar and wolf (?). In the
background a female figure and Hermes with petasus
and caduceus (herald's staff). In front of the ani-
mals a woman to left. On the shoulder palmettes.
End of sixth century B. C.

113. Lecythus from Tarentum. Reddish clay, black varnish,
applied red and white paint, incisions. Encircling
the body Poseidon riding a winged hippocamp, in his
right hand a trident. Behind the sea-horse two
dolphins indicate the ocean. On the shoulder
palmettes. About 500 B. C.

114. Lecythus. Reddish clay, black varnish, incisions. On
the body mask of Silenus, on either side a garment.
On the shoulder rays.

115. Similar. On either side of the mask an ivy-leaf.
116. Lecythus. Light brown clay, black varnish. On the
body three horses to right led by men wearing peta-
sus, short garment, and carrying lances. Meaning-
less inscriptions. On the shoulder palmettes.
117. Lecythus with white ground. Reddish clay here and
there burned black in funeral pyre. Black varnish
painting, incisions. Encircling the body the death
of Argus. Io transformed into a cow (represented
as a bull by mistake), then Hermes wearing petasus,
mantle and shoes, with kerykeion (caduceus) in right
hand, is rushing upon the falling Argus who has
two faces looking in opposite directions. A woman
(Hera?) is hurrying to his rescue. The very latest
black-figured style, about 480 B. C.
118. Lecythus with white ground from Bari. Brown clay,
dark brown varnish shading into black, superim-
posed red paint. On the body two rows of palmettes
bounded by continuous tendrils.
119. Lecythus with white ground. Reddish clay, black var-
nish painting. On the body a woman, painted in
outline, wearing chiton, himation and hood, in her
hands distaff and spindle. About 450 B. C.
120. Guttus in form of tortoise. Brown clay. On the shell
are painted crosses. Doubtful if Attic fabric.
121. Alabastrum with white ground. Reddish clay, black
varnish painting, incisions. Encircling the body a
draped female flute-player, then a draped female
dancer with crotala (castanets), then a bearded man
leaning on a staff and holding a flower, finally
another dancing woman with crotala. Below the
figure-zone is a turret-design painted in white.
122. Similar. Above the turret-design two zones filled with
network.
123. Tripod. Yellowish-brown clay. Black varnish turned
brown in the firing, wherever applied in thin coating,

superimposed red and white paint, incisions. On the feet A: Achilles pursuing Troilus. In front Polyxena is escaping to right (there was not room for her entire figure). Troilus is on horseback and is leading a second horse by the bridle. Polyxena's hydria lies on the ground under the outstretched legs of Achilles. On the left a youthful spectator, wrapped in his himation. B: Group of four youths and one woman. C: Group of two youths and four men. Two of the men are dancing, one of the youths is an athlete, as is evinced by his strigil and aryballus; on his left arm a wreath. First half of sixth century B. C.

124. Lamp, incorrectly called Kothon. Reddish clay, black varnish in places turned red in the firing, superimposed red paint. A zone of rudely drawn birds.

125. Scyphus.

126. Cylix. Reddish clay, black varnish, superimposed red and white paint, incisions. On the inside, female demon with outstretched wings on her shoulders, small wings on her red shoes, ear-ring, tænia in hair, red eyes. The pose is similar to that of the Nike of Archermus.

127. Omphalos phiale (libation saucer). Reddish clay, black varnish.

128. Pinax (plate). Brown clay, black varnish, on the inside a lighter color, incisions. On the inside a meander band cuts off a segment in which is a fox gnawing a bone. Above the segment Dionysus, carrying grapes in both hands, rides a mule.

XIII. ATTIC RED-FIGURED

Reddish clay, lustrous black glaze

129. Lecythus. Brown clay. On the body, covered with a black glaze, is painted the picture in reddish-white,

white and red. Details incised. This is a rare
method which differs from the usual red-figured
style where the pictures are the color of the ground
with details drawn in with a brush and not incised.
On the body Heracles with lion's skin and club pur-
sues an Amazon. On the shoulder which is ground-
colored, i.e. not glazed, palmette and lotus-buds.
End of sixth century B. C.

180. Bell-shaped crater (bowl for mixing wine and water).
Picture on each side, A: On a kline (couch) recline
a youth and a bearded man; each rests his left arm
on a cushion, each holds a cylix (wine-cup). In
front of the kline is a table with food, and on the
left a female flute-player with double-flutes enter-
tains them at their banquet. As usual the men are
crowned with wreaths. B: Two draped youths.
Laurel-branches encircle the lip. About 450 B. C.

181. Similar shape. A: Youthful Dionysus with torch and
staff surrounded by dancing Sileni with torches,
except one who holds a thyrsus. Attempt at per-
spective, i.e. figures at various heights. Flame of
the torches yellowish-white. B: Three draped
youths. Second half of fifth century B. C.

182. Similar shape, found in Greece. A: Eros perched on
a rock is playing on double-flutes for a dancing girl
about to ascend a small platform. B: Girl with
tympanum. Second half of fifth century B. C.

188. Similar shape. A: Dancing Mænad with tympanum and
thyrsus surrounded by dancing Sileni. B: Two
draped youths. Second half of fifth century B. C.

184. Stamnus. A: Dionysus (inscribed) fully draped,
bearded and crowned, holding thyrsus and can-
tharus, is seated on a chair covered with a skin. A
youthful Silenus (inscribed *Marsyas*), holding a
wine-skin over his left shoulder, is pouring wine from
an œnochoe into the cantharus of the god. Next

comes a Bacchante (inscribed . . . *elike*) with two
torches and finally a bearded Silenus playing a lyre.
He too is inscribed *Marsyas*. B: A draped Bac-
chante between two bearded Sileni. Second half of
fifth century B. C.

135. Amphora. A: Athena holding a lance in her left hand
and an Attic helmet in her right. B: Hermes with
caduceus and petasus hanging behind his head. Be-
tween 470 and 460 B. C.

136. Similar shape. A: A girl pursued by a youth. B:
Girl. About 450 B. C.

137. Pelike. A: Two youthful athletes with strigil in the
presence of their trainer, inscribed *kalos*. B: Youth
and bearded man. Second half of fifth century B. C.

138. Same shape. A: Head of Amazon wearing a hood,
head of bridled horse and protome of griffin. B: A
pillar between two draped figures. Fourth century
B. C.

139. Same shape. A: Bust of Amazon and head of bridled
horse. B: Two draped youths. Fourth century
B. C.

140. Pelike from Dernah in the Cyrenaica. A: Heracles in
the garden of the Hesperides. B: Iris with cadu-
ceus pursued by Silenus. The lip of this vase is
incorrectly restored; for the correct shape see no.
139. It is interesting to note that the garden of the
Hesperides was located by the ancients in the Cyre-
naica and that the same subject is painted on a
hydria of the same style.

141. Œnochoe (wine-pitcher) with trefoil mouth. Restored
from fragments. On the right a man in himation
(mantle), with laurel-branch in his left hand, in con-
versation with a nude youth leaning on a staff over
which is a piece of drapery. On the left a draped
woman. Second half of fifth century B. C.

142. Œnochoe from Apulia. Siren at an altar. About 450 B. C.

143. Œnochoe. Nude boy bending forward with outstretched arms. The position seems to indicate that he has just finished a standing broad-jump. Second half of fifth century B. C.

144. Toy œnochoe. As is customary on toy dishes the scene depicted is taken from child-life. A naked child with a band around its waist to ward off evil influence is creeping towards a pitcher. End of fifth century B. C.

145. Œnochoe with circular mouth, from Athens. Poseidon, bearded, with trident in left hand, is conversing with Theseus. About 460 B. C.

146. Lecythus from Laurium. On a three-stepped base a sphinx is seated. Beginning of fifth century B. C.

147. Lecythus. Front view of nude boy, on his right a pillar. First half of fifth century B. C.

148. Lecythus from Gela. A woman is about to put a folded dress in a chest. Behind her a chair and on the wall a mirror and a wreath. First half of fifth century B. C.

149. Fragmentary lecythus. Athena with ægis, lance in right and helmet in extended left hand. Middle of fifth century B. C.

150. Lecythus. Boreas flying to right. Middle of fifth century B. C.

151. White-grounded lecythus. This style differs from the preceding in that the figures are actually painted on a white slip and not drawn on the ground of the vase. On the left of a stele (tombstone) kneels a mourning youth in a red mantle. On the right a maiden is sitting on the ground. She wears a hood and the upper part of her garment is painted red. End of fifth century B. C.

152. Aryballus. A draped woman pouring a libation on an altar. Middle of fifth century B. C.

153. Aryballus. Between two trees with golden fruit a draped woman sitting on a rock. On the left a bird and a nude Eros, painted white with gilded wings, about to catch a golden fruit which is falling from the tree. End of fifth century B. C.

154. Aryballus formerly in the collection Catalano in Naples. A group of four deities, all inscribed, Aphrodite, Amymone, Poseidon and Amphitrite. The flesh and chiton of Amymone are painted white. The figures are on different levels. End of fifth century B. C.

155. Pyxis (toilet-box) with lid and three legs. In front of a house, indicated by a double-door between two columns, a bride, wrapped in a mantle, is sitting on a stone. The word kale is written on the stone. Three women are approaching the bride. The box may have been a wedding present. Middle of fifth century B. C.

156. Small pyxis with lid. On the lid is painted a cantharus.

157. Pyxis. Only the overlapping lid is decorated; on the top around a bronze ring four animals, a cat-like animal, a bull, a roe (?) and another cat-like animal. Between the animals are bushes painted in white.

158. Guttus from Apulia. Mouth and handle missing. On top a Silenus, bald, is creeping to left towards a ram.

159. Guttus with two mouths joined by a handle. Under the handle is painted an amphora with a pointed bottom.

160. Scyphus (wine-cup) with two horizontal handles. A: Two youths conversing. In the field two crosses and a bag. B: Similar subject carelessly drawn. The vase was repaired with bronze rivets in ancient times. First half of fifth century B. C.

161. Scyphus, one handle horizontal, the other vertical. From Bari. Covered with black glaze except the

base-ring and the vertical handle which is decorated with a palmette.

162. Scyphus. From Greece. Bearded dwarf dancing before a scyphus. Well drawn. Second half of fifth century.

163. Scyphus. On each side an owl.

164. Cylix (wine-cup). Inside: A youthful athlete about to jump. He is swinging halteres. The upper part of his body is seen from behind. In the field meaningless inscription. About 500 B. C.

165. Cylix. Inside: Symposium, young man and girl with double-flutes. Inscribed *ho pais kalos*. About 500 B. C.

166. Cylix. Inside: Youth playing on double-flutes before an altar on which burns a fire. Inscribed *ho pais kalos*. About 460 B. C.

167. Cylix from Bari. Inside: Draped woman; behind her a door (?), in front of her a basket (?) only partially visible. The mirror on the wall indicates an in-door scene. Middle of fifth century B. C.

168. Cylix. Inside on a segment of a circle stands a bearded man leaning on his staff, about to decorate a rock (tomb?) with a branch which he is shaping into a wreath. Behind him traces of a monument on two steps. About 450 B. C.

169. Cylix. Inside on a segment a bald Silenus watching in ecstasy a stream of wine flowing from the spout of a vessel not indicated. Inscribed *kalos*. Second half of fifth century B. C.

170. Lid of a cylix. Twice repeated: A griffin facing the bust of a barbarian with Phrygian cap. Fourth century B. C.

171. Pinax (plate). Inside on a line Ajax (inscribed *Aias*) about to drag Cassandra (inscribed *Katadra*) from the statue of Athena (inscribed *Athenaia*). About 500 B. C.

172. Pinax with two small holes for suspension. Inside: Dionysus with cantharus and pronged twig entertained by a dancing Silenus. This and the preceding plate, no. 171, were decorated by the same artist.

XIV. Vases in the Form of Various Objects

Period of red-figured vases

173. Female head. Handle and mouth of vase cut off in modern times. About 500 B. C.
174. Group of three mussel-shells.
175. Almond.
176. Almond.
177. Lobster-claw covered with white slip.
178. Alabastrum of brown clay in imitation of snake's skin. The scales are touched with white.
179. Amphoriscus of brown clay. Reticulated design with white dots in the meshes.

XV. Bœotian

(a) *Orientalizing*

180. Cantharus covered with yellowish-white slip. Dull black varnish and red paint. Geometric design. On the lip A: two flying birds; B: two palmettes.
181. Bowl with one handle and three protuberances opposite the handle. Yellowish-white clay, dull black varnish and red paint. Outside above the foot rays and pot-hooks project.
182. Shield. Reddish clay, white slip. Yellow rim, red and black circles, in the center a red dot. Handle on inside.
183. Shield. Yellow clay, white slip. As shield-device a star with eight rays alternately red and black. Handle on inside broken off.

(b) *Early black-figured*

184. Pitcher with trefoil mouth. Imitation of metal-ware. Brown clay, black paint, applied red. Linear design.

185. Cantharus. Light brown clay, dark brown varnish, superimposed red and white paint, incisions. A: Six dancing men, one playing on double-flutes. In the field a lyre. B: Similar subject.

186. Cantharus. Brown clay, black varnish, superimposed red paint, incisions. On each side four men, two with wine-cups.

187. Scyphus. Black varnish, superimposed red paint, incisions. In front of a temple an altar with fire, approached by a man with victim, a woman (?) with basket on her head, two men (?) with branches. On the right of the temple an unidentified object. Very rude drawing.

188. Cylix. Light brown clay, brown varnish shading into black, superimposed red and white paint, incisions. Outside two zones of ivy-leaves and linear designs. Inside panther.

(c) *Cabirian*

189. Scyphus. Brownish clay, brown varnish painting shading into black. Outside below the lip ivy-vines; above the foot dotted circles, half-circles, ivy-leaves and a rudely drawn bird upside down. End of fifth century B. C.

(d) *Late black-figured*

190. Œnochoe with trefoil mouth. Brown clay, black varnish painting. Around the body ivy-wreath.

191. Œnochoe with circular mouth. From Greece. Light brown clay, black varnish. Body fluted, shoulder black with incised sprigs of ivy, red leaves. Identification uncertain.

192. Dinos. Brown clay, dark brown varnish. On the

bottom cylindrical protuberance, below the lip ivy-wreath.

198. Bowl. Brown clay, dark brown varnish. On the body, swastika, caduceus and wreaths. Near the lip two holes for suspension. It is therefore probable that the vase was a votive offering.

194. Cylix. Brownish clay, black varnish. Outside below the lip palmette and lotus decoration. Swastikas in the field.

195. Lecythus in form of mussel-shell. Brown clay. Lustrous dark brown varnish.

(e) Red-figured

196. Bell-shaped crater. Light brown clay, reddish slip. A: Athena. B: Hind. Second half of fifth century B. C.

XVI. "MEGARIAN" BOWLS (third century B. C.)

197. Light brown clay, dark brown varnish. Four feet in form of mussels. On the bottom rosette. Outside in four vertical divisions grapes, leaves and tendrils.

198. Acquired in Saloniki. Reddish clay, reddish-brown varnish shading into dark brown. On the bottom head of Gorgo. Outside (a) Dionysus with satyr and mænad; (b) flying Nike (?); (c) man and girl; (d) Eros; (e) female figure; (f) Apollo playing lyre; repetition of c, b and d, a, c, d, e, f, c; (g) dolphin; repetition of b and d.

199. Acquired in Saloniki. Reddish clay, dark brown varnish. On the bottom rosette. On the body outside (a) Heracles and the Nemean lion; (b) Dionysus on panther attacking a giant; (c) armed deity (?); (d) fallen warrior; (e) Athena attacking a giant with serpent-shaped legs; (f) trophy between two goddesses of victory; repetition of a, b, c, e; (g) Athena putting her helmet on her head.

200. Light brown clay, black varnish. On the bottom rosette. Above between two rams an amphora and a ram's head; this group is repeated four times with flying cupids, masks and grapes between the groups.

201. Acquired in Saloniki. Light brown clay, reddish varnish shading into black. On the bottom rosette. The body fluted; in two of the flutings is stamped the inscription *polemonos*.

202. Same material and color. Rosette and floral design.

203. Same. Similar design.

204. Similar.

205. Brown clay, dark brown varnish. On the bottom rosette and calyx; above Eros and boy alternating.

206. Light brown clay, black varnish which for the most part has turned reddish-brown in the firing. Rosette and calyx, zone of rosette and double-palmette alternating.

207. Grey clay, dark brown varnish. On bottom plastic ring, above this leaves and caduceus alternating.

208. Brown varnish shading into dark grey. Partly fluted. Classified under "Megarian" bowls merely because of its shape.

209. Brown clay, brownish varnish. Similar design. Inside roughened by insertion of small stones. Not "Megarian," but placed here because of the form.

210. Pitcher. Grey clay, dark brown varnish. The upper part of the body made in a form. Neck broken away. Body pierced with five holes. No trace of handle. For the decoration compare no. 204.

XVII. LATE GREEK

Miscellaneous

211. Amphora with grooved handles. Greyish-brown clay. On the body in relief between bunches of grapes, A: Athena. B: Aphrodite (?).

212. Amphora from Smyrna. Light brown clay, black varnish poorly preserved. On each side birds in grape-vines.

213. Pitcher, according to report from Clazomenæ. Brown clay. Part of the body fluted horizontally. On the shoulder incised inscription *tyche*.

214. Bowl with two handles. Light brown clay. Brown varnish shading into black. Twigs of ivy in barbotine technique.

215. Cup with two handles from Thyatira in Lydia. Brown clay. The body below the handles is covered with dots.

216. Cup from same place, one handle broken away.

217. Bowl from Corinth. Brown clay. Reddish-brown varnish shading into black. Encircling the body in relief: Heracles and nymphs; satyr and ram (?); man about to pour libation on altar; column, trees, altar (?), satyr, cliffs, three-legged table. Between the figures grape-vines.

XVIII. Early Italic

218. Dinos and its supporting base. The support is of coarse reddish clay, white slip, with linear decoration in red paint. The dinos itself is of coarse grey clay covered with red slip.

219. Pitcher with strainer of five holes in the spout. Brown clay. Wavy vertical fluting.

220. Upper part of pithos. Light brown coarse clay, reddish slip. Middle part of body was fluted, above this a zone with stamped reliefs in a rectangular field, centaur with human forelegs; gorgo-head; griffin; repeated eight times; above this overlapping semicircles.

221. Bowl with high handle of angular shape. Dark brown clay. Outside below the lip a row of indentations, inside incised rays.

222. Platter. Coarse brown clay. On the rim stamped reliefs, consisting of a group of three birds repeated seven times and part of an eighth group. Above the birds an Etruscan inscription *lari screpus m.*

XIX. Bucchero

223. Urn with lid. On pointed projections a number of figurines (women, foreparts of griffins), which presumably were found along with the urn, have been placed.

224. Bowl with high foot and lid. Near the lip eight heads in relief: a ram's head and a female head alternating. On the lid five female heads in relief, and incised linear decoration.

225. Goblet. Brownish-black paste. Incised linear ornamentation.

226. Cylix. Lustrous black. Fine technique, incised lines.

227. Similar, but plastic ring instead of foot.

228. Support for a dinos? Red clay, black slip. Above the ring-shaped foot and below the six looped handles the body is pierced with six holes. Turned upside down it may have served as a brazier.

XX. Italo-Corinthian

229. Lecythus. Reddish clay, reddish varnish shading into dark brown. Part of the mouth is missing.

230. Bowl with one handle. Brown clay with flakes of mica. Reddish varnish.

231. Plate. Whitish clay, reddish-brown varnish. Inside dot and concentric circles. Unidentified fabric.

XXI. Italo-Ionic (sixth century B. C.)

232. Amphora. Brown coarse clay, dark brown varnish painting, incisions. A: Lion. B: Fallow-deer.

283. Amphora with lid. Reddish clay, brown varnish paint-
ing shading into black, incisions. A: Bearded
monster, lower half of body in form of fish (*halios
geron?*) attacked by a swimming bearded man
(Heracles?). Three fish and a wavy line indicate
the water. B: Deer attacked by two wolves (?).

284. Amphora. Yellowish clay, reddish-brown varnish shad-
ing into black, incisions. Encircling the body, a
nude boxer and his fallen opponent wearing loin-
cloth. The projecting index-finger of the latter
indicates his defeat. The umpire is hurrying to the
scene. To the right of this group a warrior with
loin-cloth, shield and helmet is hurling a lance at a
mark. By the rippling of the shaft the painter evi-
dently intended to represent the quivering of the
weapon as it is about to pass through the air. He
too is watched by an umpire. Two examples of this
rare fabric are in the Metropolitan Museum, New
York.

285. Amphora. Reddish clay, black varnish with a metallic
glaze, superimposed red and white, incisions. A:
Man running to left, behind him a siren. B: Man
and siren confronted.

286. Amphora-shaped pitcher with a handle diametrically
across the mouth. This arrangement of handle is
very rare. Reddish clay, lustrous black varnish
painting. On the shoulder four buds and two leaves.

287. Œnochoe with circular mouth. Yellow clay, reddish-
brown varnish shading into black wherever applied
in a thicker coat.

288. Œnochoe with trefoil mouth. Yellowish-brown clay,
black varnish. On the shoulder three buds marked
with white.

289. Crater. Brown clay, black varnish, superimposed red
paint. Row of ivy-leaves alternately black and red.
Foot restored, but too high.

240. Plate. Light brown clay, reddish varnish shading into black. The decoration consists of circles, buds and palmettes.

XXII. EARLY APULIAN (about 800-600 B. C.)

241. Crater with volute-handles, from Bari. Yellow clay, dull brown varnish shading into red. Ring and dot decoration. Greek influence.

242. "Torzella." Yellow clay, reddish-brown varnish shading into dark brown. Reticulated lozenge pattern. On the handle-disks crosses. Messapian fabric.

243. "Torzella." Light yellow clay, well-polished surface, reddish-brown varnish. On each side three metope-like divisions on the shoulder, filled with flowers and palmettes. Greek influence.

244. "Torzella." Light yellow clay, dark brown varnish. On each side five reticulated lozenges on the neck. Greek influence.

245. Amphora with handles projecting horizontally. From Bari. Light brown clay, dull black paint. On the bottom star, on the body swastika and lozenges. Peucetian fabric.

246. Bowl-shaped vase with cup-shaped lid. Brown clay, white slip, dull black paint. Linear patterns, on the lip a small quadruped (hare?). The two protuberances between the handles have the shape of five fingers. Under Greek influence.

247. Pitcher, hand-made. Brown clay, dull black and red paint. Reticulated triangles and curved lines.

248. Similar.

249. Ascus from Apulia, hand-made. Light brown clay, dull black and red paint. Linear decoration. Daunian.

250. Ascus from Apulia. Light yellow clay, dark brown paint. Linear designs. Daunian under Greek influence.

251. Ascus with two mouths, pierced with small holes as a

sieve. Light brown clay, dark brown paint. On the shoulder garland of ivy below pot-hooks, then reticulated zone, chain pattern and below snail-like figures, fish and rosettes. Daunian under Greek influence.

252. Ascus. Brown clay, white slip, red paint. Open bottom and slit top, therefore not meant for actual use.

258. Bowl with two handles, hand-made. Light brown clay, dark brown and red paint. Linear decoration.

254. Bowl with two handles, from Apulia. Also hand-made. Greenish-yellow clay, dark brown paint.

255. Bowl with two handles, from Bari. Light yellow clay, brown varnish. On each side between the handles ivy-vines. Under Greek influence.

256. Bowl with two handles close together. Light brown clay, dull black and red paint. Hand-made. Lozenge pattern. Daunian fabric.

257. Ladle from Bari, hand-made. Light brown clay, dark brown and red paint. On the bottom and the sides linear designs.

258. Bowl with one handle, hand-made. Greenish-yellow clay, similar colors and decoration.

XXIII. APULIAN RED-FIGURED

(a) *Painted design*

259. Lamp, incorrectly called Kothon. Light brown clay, applied red paint on black varnish. Laurel-twig.

260. Cylix. Light brown clay, red slip, applied red paint on black varnish. Conventionalized flowers.

261. Cylix. Brown clay, red slip. Outside laurel-twig, inside laurel-wreath and a swan painted in red on black varnish glaze.

262. Cylix from Bari. Light brown clay, red slip. Both outside and inside laurel-wreath painted in red on black glaze. In the center a rosette of eleven leaves.

(b) *Ground-colored figures*

263. Pelike. Superimposed yellowish-white paint for attributes. A: Youth between two female figures, cupid above, fawn below. B: Similar picture, fawn missing.

264. Pelike. Superimposed white paint for attributes. A: Female figure sitting on a rock. B: Head of woman.

265. Œnochoe from Apulia. Draped youth running to right.

266. Cantharus. Superimposed yellowish-white paint. A: Eros. B: Nike. Plastic heads on handles at juncture with lip.

267. Scyphus from Bari. A: Silenus. B: Draped female figure. Imitation of Attic ware dating from the second half of the fifth century B. C.

268. Cup. Applied yellowish-white paint for ornaments. Head of woman.

269. Lecythus from Lecce. Applied white and yellow paint. Draped female figure sitting on a stool; facing her stands Eros with a swan.

270. Lecythus from Lecce. On a heap of stones a draped female figure is seated; behind her stands Eros resting one foot on another heap of stones.

271. Cylix. Applied yellowish-white paint for attributes. Outside, between the handles, on each side head of a woman. Inside woman seated on a heap of stones, in her right hand mirror, in her left basket with lid and pail (situla).

272. Bowl with two handles. Applied yellowish-white paint. Outside A: Female and male figure, seated. B: Seated female figure and Eros hovering over her. Inside seated female figure, Eros hovering over her and youth offering her gifts.

273. Plate (pinax) from Bari. Applied yellowish-white color. Inside head of woman.

274. Plate from Apulia. Inside bearded head almost full face.
275. Plate. Superimposed yellowish-white paint for ornaments. Inside head of woman full face.

XXIV. So-Called Gnathian Ware

Brown clay, decoration in white, in yellowish-white or yellow, and in red on black glaze

276. Amphora from Bari. Body and shoulder fluted. Bird and ivy-vine.
277. Amphora. Swan.
278. Pelike. Female head, wings on shoulders.
279. Œnochoe with trefoil mouth. Grape-vines and bunches of grapes, alabastrum and wreath.
280. Similar.
281. Similar, from Lecce.
282. Similar.
283. Œnochoe. Body fluted, on shoulder spray of ivy.
284. Œnochoe with circular mouth, body fluted. Spray of ivy.
285. Pitcher with beak-shaped mouth and two plastic masks at upper end of handle. Twigs, rosettes, etc.
286. Similar. Grape-vines and grapes, bird in trap.
287. Pitcher with pyxis-shaped body and mask of Pan at upper end of handle. From Lecce. Laurel-branch on body, woman with double-flutes and swan on shoulder of vase.
288-289. Similar.
290. Scyphus. Grape-vines and grapes, rosettes, etc.
291. Scyphus from Bari. Spray of ivy incised.
292. Similar. Grape-vines and grapes.
293-294. Similar.
295. Scyphus. Three sprays of ivy incised.
296. Similar, from Apulia.
297. Lecythus. Tendrils, acanthus, flowers, etc.

298. Similar, from Lecce. Head of woman.
299-802. Lecythi with reticulated decoration.
808. Lecythus with fluted body in two divisions.
804. Similar. At lower end of handle plastic mask.
805. Ascus from Bari. Incised lines, rosettes, etc.
806. Bottle with fluted body.
807. Cantharus with fluted body.
808. Cylix from Apulia. Inside in the center plastic rosette.
809. Alabastrum with fluted body.

XXV. APULIAN WITH YELLOW SLIP

810. Œnochoe originally made with hole in bottom, therefore not for practical use. At each end of handle bearded head.
811. Similar, but handle ends in volutes.
812. Pyxis with flat lid.
818. Omphalos phiale (libation-saucer), from Bari. Slip only inside.
814. Plate with five projections on rim, and two holes for suspension.
815. Pan with snake as handle.
816. Similar with plain handle.
817. Similar, handle ending in swan's head. Slip almost entirely worn away.

XXVI. CANOSA WARE

818. Crater with volute-handles decorated with female masks. Brown clay, white slip. Antique repairs on foot.
819. Flask. Light brown clay, white slip, red and blue paint. Wreath around middle.
820. Bowl with flaring mouth and one handle. Light brown clay, white slip. On body plastic female head, touched up with black and red paint. On her head stands a terra-cotta figurine of Pan. At lower end of handle plastic female head.

XXVII. Miscellaneous Apulian

321. Ascus from Bari. Light brown clay, black varnish almost entirely worn away. Open bottom. On body reliefs were pasted, now partly missing. Between a wave-pattern Amazonomachy of which are preserved (a) warrior (twice), (b) Amazon (thrice). On neck reliefs of griffin, lion and sphinx are pasted.

322. Cup with two handles. Reddish clay, black glaze, applied white paint. Upright twigs, black on red and white on black. Below wave-pattern and egg and dart.

323. Cup with one handle, from Apulia. Yellowish-grey clay. Owl painted in white on black glaze.

XXVIII. Lucanian Red-Figured

324. Bell-shaped crater. Light brown clay, black glaze background. A: Youthful figure (Dionysus?) with thyrsus, Artemis (?) and bearded Pan, draped. B: Three youths. About 400 B. C.

325. Similar. A: Youth on horseback attacking Amazon on foot. B: Youth in conversation with woman and Silenus.

326. Amphora. A: Centauromachy; one warrior to left, with two left hands by mistake, fighting against two centaurs. Imitation of Attic "Polygnotan" style, about 450 B. C.

XXIX. Calenian

327. Bowl. Black glaze. Inside medallion, bust of winged satyr (?) in high relief.

328. Libation saucer (omphalos phiale). Light brown clay, black glaze. Around the protuberance an inscription L.CANOLEIOS.L.F.FECIT.CALENVS., and a relief, the rape of Proserpina: Hermes in front of biga driven by Pluto holding Proserpina in his arms;

Athena in front of biga driven by Demeter; Ares (?) in front of biga driven by Enyo (?); Aphrodite (?) in front of biga driven by Nike.

829. Similar shape. Inside in relief a mass of queer figures, winged female creatures with leaves instead of legs, foreparts of winged lions, geese and rabbits.

830. Similar shape, inscribed as no. 828. Stamped leaf pattern.

XXX. CAMPANIAN

(a) *Small cups on ring-shaped base*

831-833. Light brown clay. From Teano.

(b) *Bowls from Teano*

834. Light brown clay, red slip, black glaze. Stamped designs.

835. Reddish clay, black glaze, applied white paint. Stamped and painted designs.

XXXI. ITALIAN RED-FIGURED

Miscellaneous

836. Amphora. Light brown clay, red slip, black glaze, superimposed white paint. A: Seated woman weeping at a tomb, in the background two youths. On the neck woman with wreath and box, behind her a pillar. B: Two youths seated on the ground and a standing female figure.

837. Lecythus. Female figure running to right.

838. Scyphus. Red slip, black glaze. Two owls and an olive-branch.

839. Similar. On each side an owl between branches.

840. Pyxis with overlapping lid. Black glaze. On the top of the lid head of Amazon with Phrygian cap. Perhaps Greek fabric.

341. Spherical vase with lid. On lid head of woman, white ornaments.

342. Cylix. A nude youth seated on a cliff, his hands on his knees, looking at a pillar (tombstone?). Magna Græcia, end of fifth century B. C.

343. Cylix and lid not belonging to it. The cylix is of grey clay, the lid of reddish clay, black glaze, applied white paint. On top A: Eros and hare; B: Woman seated on a cliff. A and B are separated by palmettes.

344. Plate. Light brown clay, black glaze.

345-347. Fish-plates. Brown clay, lustrous black glaze, and applied white for fins, gills and eyes of the fish. Cup-shaped depression in the middle for the sauce.

XXXII. Late Etruscan

348. Amphora from Orvieto. Brown clay, silver-plated. On the shoulder in relief, imitating repoussé work, Amazonomachy of two groups repeated four times, A: Warrior to right attacking an Amazon who has dismounted. B: Warrior to left dragging an Amazon by the hair. Once in group B a second Amazon comes to the aid of the one who is being dragged.

XXXIII. Italian and Sicilian

Hellenistic period

349. Pitcher. Light brown clay.

350. Rhytum from Bari. Brown clay, white slip. The horn ends in a griffin's head.

351. Rhytum. Light brown clay, white slip. Bull's head.

352. Lecythus from Bari. Light brown clay, white slip painted in the manner of terra-cotta figurines. Body in form of hippocamp; on its back a Nereid carrying a greave. Another Nereid (or Thetis) holds a shield.

853. Cantharus. Light brown clay, white slip, originally
 gilded.
854. Cantharus. Light brown clay. Part of body fluted.
855. Alabastrum of Egyptian shape except foot. Light
 brown clay.
856. Ampulla. Brown clay, reddish slip on upper part of
 neck.
857. Plate. Brown clay, traces of red glaze.

XXXIV. GUTTI WITH BLACK GLAZE AND RELIEFS

Various centers of manufacture

858. From Greece. Head of negro. Greek fabric.
859. Reddish clay, dull glaze. Floating figures of youth
 and girl. Greek fabric.
860. Bottom painted red. Head of Dionysus.
861. Light brown clay, traces of red on bottom. Lion
 attacking deer on Ionic capital.
862. Body fluted.
863. Light brown clay. Bottom not glazed. Female head.
864. Brown clay. Mask of Silenus. Partly fluted.
865. Light brown clay. Similar.
866. Brown clay. Female head.
867. Brown clay, iridescent glaze. Head of Omphale with
 lion's skin.
868. Brown clay. Mask of Silenus.
869. Brown clay. Nereid with shield on hippocamp.
870. Brown clay. Heracles as a child strangling the snakes.
871. Brown clay. Female head in high relief.
872. Similar.
873. Brown clay. Head of Athena wearing Corinthian
 helmet.
874. Brown clay, lustrous dark brown glaze. Youthful head
 with ivy-wreath.

XXXV. Black-Glazed Ware

Greek or Italian under Greek influence

875. Amphora. Light brown clay, red slip on foot.

876-877. Hydriæ. Reddish clay.

878. Hydria from Apulia. Light brown clay.

879. Œnochoe with beak-shaped mouth. Light brown clay.

880. Similar, but no foot.

881. Pitcher. Light brown clay, dull glaze. Italian fabric.

882. Pitcher with trefoil mouth. Light brown clay, red slip on bottom.

883. Pitcher with pyxis-shaped body. Light brown clay.

884. Lecythus with egg-shaped body. Light brown clay, traces of red slip. Fluted in front.

885. Lecythus with semi-globular body. Fluted almost vertically.

886. Pyxis with flat lid. Light brown clay. The inside of the box has brilliant red glaze.

Canthari

887. Reddish clay. Gilt rim at juncture of handles. Around body gilt ivy-wreath.

888. From Lower Italy. Light brown clay, applied red and yellowish-white paint. Vertical grape-leaves and tendrils. Inside on bottom four stamped palmettes and circles. Closely related to Gnathian ware.

889-890. Brown clay. Inside on bottom stamped design as on no. 388.

891. Light brown clay, lustrous glaze. Body fluted.

892. Similar, dull glaze.

893. Vertical handles ending above in flat projections for the thumb. Metallic glaze.

894. Reddish glaze. Inside on bottom stamped circles.

Scyphi

395. Light brown clay, traces of red slip. On bottom dot and circles.
396. Reddish clay. Similar decoration. Greek fabric.
397. Light brown clay. Similar decoration on bottom and incised meaningless (?) inscription. Nearer the rim incised *eu*.
398-405. Light brown clay, red slip. On bottom dot and circles.

Cups

406. Brown clay. Italian fabric.
407. Light brown clay. Body fluted vertically.
408. From Apulia. Light brown clay, red slip. Fluted horizontally.
409. Goblet. Light brown clay.
410. Miniature crater. Light brown clay.

Cylices without handles

411. Light brown clay. High foot.
412-414. Reddish clay.
415. Light brown clay.
416-423. Reddish clay. On no. 423 the letter A is incised.
424. Light brown clay, traces of red slip. Ring-shaped foot.
425-426. Reddish clay.
427. Light brown clay, iridescent glaze.
428. Libation saucer. Light brown clay. Fluted outside.

Cylices with one handle

429. Light brown clay. On bottom letter E painted in red.
430. Reddish slip.
431. The black glaze has for the most part turned red in the firing.

Cylices with two handles

432. Reddish clay, thin section. Vertical handles. On inside stamped rosette. Greek fabric.

438-439. Reddish clay, only partly glazed. Horizontal handles.

440. Reddish slip. On the bottom meaningless (?) graffito.

441-442. Similar, without graffito.

443. Similar, but no slip. On the bottom are incised two marks.

444. Reddish slip.

445. Similar. Greek fabric.

446. Light brown clay.

447. Bowl with lid. Reddish clay. Greek fabric.

448. Similar, but differently shaped handles.

Gutti without medallions in relief

449. Brown clay. Bottom not glazed.

450. Ring-shaped handle. Brown clay. On top, in the center, pierced with holes like a sieve.

Aryballi

451. Light brown clay. Bottom not glazed.

452. Reddish clay.

453. Suction-vase, globular-shaped. Light brown clay, reddish slip. Bottom not glazed. In the middle of the bottom a hole, connected by a tube with the inside. Near the top a long spout.

Vases in form of various objects

454. Dog. Light brown clay, traces of white on his eyes. Inlet above his neck, outlet through his muzzle.

455. Crouching negro. Light brown clay. He wears a panther's skin over his head, and is filling a vase, which he holds in his right hand, from a wine-skin. Knotted handle.

456. Astragalus. Light brown clay, entirely glazed. Outlet connected with two handles on the narrow end.
457. Astragalus. Outlet on broad side. Knotted handle.

XXXVI. BLACK-GLAZED ITALIAN

458. Goblet-shaped crater. Light brown clay, metallic glaze.
459. Flask. Reddish clay. Open below, therefore not for practical use.
460. Egg-shaped flask. Reddish-yellow clay, metallic glaze. On body and neck red and white rings.
461. Jug. Light brown clay, lustrous glaze.
462. Lecythus. Brown clay. Oval-shaped body.
463. Lecythus. Metallic glaze.

Cylices without handles

464–465. Ring-shaped foot. Light brown clay.
466. High foot. Brown clay, metallic glaze.
467. Cylix with one handle. Brown clay, metallic glaze.
468. Cylix with two handles. Light brown clay, red slip on bottom.

Plates

469. Light brown clay, dull glaze.
470. Similar, metallic glaze.
471. Brown clay.
472. Fish-plate. Light brown clay, metallic glaze.

XXXVII. STAMPED BLACK-GLAZED

(a) Greek or Italian under Greek influence

473. Amphora. Stamped palmettes and incised rings.
474. Guttus. Light brown clay. Body fluted. On top a little lid so arranged that it is locked to the body if slightly turned after insertion. Mouth in form of lion's head. Palmettes.
475. Bowl. Light brown clay, bottom not glazed. Body

fluted. Stamped circles, palmettes and egg and dart moulding.

476. Similar.

477. Similar. Stamped meander.

478. Cylix without handles. Reddish clay. Palmettes. Probably Italian fabric.

479. Cylix with two handles. Brown clay. Inside circular egg and dart moulding surrounded by palmettes.

480. Similar. Reddish clay. Inside incised circle surrounded by four palmettes. Greek fabric.

481. Similar. Light brown clay, red slip. Five palmettes, incised inscription *Maceissim*.

482. Similar. Inside rosette surrounded by palmettes.

(b) *Italian*

483. Amphora. Light brown clay, greyish-black dull glaze. Palmettes and meander.

484. Lecythus. Light brown clay, metallic glaze. Palmettes.

485. Cup with one handle. Red slip, metallic glaze. In the middle of the body six depressions and between them stamped palmettes.

486. Cylix without handles. Light brown clay, metallic glaze. Meanders and palmettes.

487. Similar. Female head and palmettes.

488. Similar. Meander, palmettes and Medusa-masks.

XXXVIII. BLACK-GLAZED HELLENISTIC

489. Crater. Light brown clay, .dull brownish glaze. Handles in form of coiled snakes. On lip plastic egg and dart moulding.

490. Amphora. Light brown clay, dull black glaze.

491. Lecythus. Brown clay, traces of red slip, dull glaze. At base of neck egg and dart moulding, from which rays filled with stamped circles diverge. Probably Elean fabric.

492. Lecythus. Light brown clay, red slip, dull glaze. Body fluted.

493. Pyxis with overlapping lid, and three feet in form of lion's claws. Glaze worn away. On top of lid bust of Dionysus in high relief.

494. Cup with two vertical handles. Light brown clay, traces of red slip. Lower part of body fluted horizontally.

495. Similar. Brownish-black glaze.

496. Similar, but not fluted.

497. Cantharus. Brown clay, reddish-brown glaze shading into black.

498. Scyphus. Light brown clay, red slip.

499. Globular-shaped vase on large foot. On the body, which is divided into incised pentagons, an eagle's head is modelled.

500. Globular-shaped vase with high hollow handle which pierces the walls of the vase. The bottom is arranged as a sieve, and there is a hole in the handle. By placing the thumb over this hole the sprinkling from the bottom of the vase may be stopped.

501. Globular-shaped vase with low foot, ring-shaped handle and trefoil spout. Light brown clay, dull brown glaze shading into black. On top a comic mask.

502. Oval-shaped vase with funnel-shaped mouth projecting from the middle of the body. Light brown clay, dull glaze.

XXXIX. BLACK-GLAZED HELLENISTIC WITH APPLIED WHITE PAINT

503. Amphora pointed at the bottom. Reddish clay. Sprays of ivy.

504. Ampulla. Light brown clay. On the body between two white rings reticulated quadrangles in yellow.

505. Pitcher with circular mouth. Handle knotted at upper end. Brown glaze shading into black. On the shoulder the glaze is scratched away in places and red paint applied; between are sprays of ivy.

506. Ascus from Megara. Head of mule with hole in open mouth, bridle painted in white. Red and white linear and floral decoration on body. On either side two bearded comic masks are modelled. Between mule's head and mouth of vase an arched handle.

507. Pyxis with overlapping lid, from Canea, Crete. Dark brown glaze. On the sides of the lid incised ivy with white leaves; on top around the head-shaped knob incised reticulated and checker pattern from which incised garlands with white dots and rosettes diverge; the intervening spaces are filled with white ivy-leaves on incised stems.

508. Cup with two handles, from Rome. Light brown clay, dull brownish glaze shading into black. At the lip incised undulating line with white ivy-leaves.

509. Bowl from Apulia. Dull glaze. Inside, near lip, two white rings, outside two incised rings.

XL. TERRA SIGILLATA

(a) *Roman-African, not genuine sigillata*

510. Amphora, said to have come from Rhodes. Red clay. On each side a centaur whose equine body ends in leaves; on the back of each rides an Eros. One centaur is bearded and has both hands uplifted, the other is youthful and plays on double-flutes.

511. Oval-shaped vase with one handle. From Rhodes (?). Red clay. On the body three branches; between them cock and Dionysus. Vases of the same fabric have been found at Hadrumetum, Africa.

(b) *Miscellaneous, not genuine sigillata*

512. Cylix from Rome. Light brown clay, red slip. On the rim plastic masks and animals.
513. Ascus. Light red clay. Circular inlet and pointed tubular outlet.
514. Similar, but darker clay. Handle broken away.
515. Similar, but more elongated body. Handle and mouth restored.

(c) *Greek red ware*

516. Pitcher. Red clay, dull red slip.
517. Similar, but more globular in form.
518. Plate, from Rhodes (?). Reddish clay, dull red slip.
519. Similar.

(d) *Italian*

520. Ascus. Red slip. On the handle near the mouth retrograde stamped inscription, LEOE. The same Etruscan inscription is stamped on a vase from Arezzo.
521. Cup from Apulia. Dull red slip. On the bottom stamped inscription of two lines SEX(ti) ANN(i). Sextus Annius worked in Arezzo.
522. Cup. Light red lustrous slip. Stamped on bottom ENNI.
523. Cup. Red slip of various shades.
524. Cup. Dull red slip. Stamped in bottom VILLI. Villius worked in Arezzo.
525. Cup. Reddish clay, light red slip. On the rim four rosettes, in the bottom stamped inscription PI . . . RE.
526. Oval-shaped bowl. Dull red of various shades.
527. Plate from Naples. Light brown clay, light red slip. Central piece of a large plate. Bottom only partially covered with slip. Stamped on the inside twice RASN (Rasinii) and twice APEA.

528. Plate. Dark red slip. Central piece. Stamped retrograde inscription ARE.

529. Mould. Light brown clay. On the body garlands, bucrania and birds.

530-531. Similar.

(e) *Roman Gaul (Germany)*

532. Bowl. Reddish clay, dark red slip. Leaves in barbotine technique.

533. Cup from Andernach. Reddish clay, light red slip. Stamped OCIIL or OCIN.

534. Cup. Brown clay, light red slip.

535. Cup from Cologne. Leaves in barbotine technique.

536. Bowl. Red clay, light red slip.

537. Bowl from Cologne. Lustrous red slip. Leaves in barbotine technique.

538-539. Bowls. Dull red slip. Similar design.

540. Plate. Dull red slip. Stamped CASTVS . FE(cit). Castus worked in La Graufesenque.

541. Similar. Stamped OF(ficina) CASTI.

542. Similar. Stamped PONTI M(anu?).

543. Similar. Stamped OF(ficina) COCI. Cocus worked in La Graufesenque. On the outside are traces of the potter's fingers.

544. Plate from Andernach. Red slip. Stamped MACCARI.

545. Similar. Stamped PRIMIC(eni) SV.

546. Similar. Stamped OF(ficina) MVRAN(i).

547. Cup from Cologne. Reddish clay, light red slip. Tendrils in barbotine technique. Painted inscription REPLE. Late Imperial period.

548. Bowl from Melun. From left to right: (a) herm and beardless head below; (b) beardless mask and female figure below; (c) Apollo; (d) Satyr; (e) Satyr in circle and Eros below; (f) Apollo? These

types occur four times. Inscribed CENSORINI.
Censorinus worked in Lezoux.

549. Bowl. Lion and captive alternating, the former seven
times, the latter six times. Stamped retrograde
inscription COMITIAL(is). Comitialis was a
potter in Rheinzabern.

550. Bowl from Mainz, found in 1810. Floral designs.
Rheinzabern (?) fabric.

(f) *Fragments of forms and modern casts*

551. Light brown clay. Round hole in bottom. From left
to right: (a) Perseus with head of Medusa, bearded
man; (b) bird in circle; (c) sea-monster in form of
bull, and panther below. These groups are repeated.
Stamped retrograde inscription EPPILLII. Eppil-
lius worked in Lezoux.

552. Light brown clay. Three small holes in bottom.
Rabbits and floral designs. Probably from Lezoux.

XLI. Roman

553. Amphora. Brown clay, yellowish-brown glaze.
554. Amphora. Brown clay. Not glazed.
555. Jug. Brown clay.
556. Pitcher from Rome. Brown clay. On the body eleven
rings in pierced projections.
557. Flask. Brown clay, dark brown glaze above.
558. Scyphus, vertical handles with thumb-rests. Brown
clay.
559. Similar. Reddish-brown clay.
560. Scyphus,᾽ handles broken off. Light brown clay, lus-
trous brown glaze. Floral pattern in barbotine
technique.
561. Similar shape and design. Brown clay, dark brown
glaze.
562. Similar. Reddish glaze.

· 563. Scyphus from Rome. Greater part of lip and one handle missing. Yellowish clay, red glaze. Graffito of owner CHRYSANTI SVM.

564. Similar. Brown clay.

565. Scyphus with scalloped lip. Brown clay.

566. Cup. Clay varies in color from red to black.

567. Cup. Light yellow clay, light brown glaze.

568-569. Similar.

570. Cup. Light brown clay.

571. Bowl. Brown clay, brown glaze.

572. Bowl. Yellowish clay, red glaze shading into black. On the outside are traces of the potter's fingers.

573. Bowl. Dark grey. Leaf pattern between dotted rings in barbotine technique.

574. Bowl. Reddish clay.

575. Cylix. Dark greyish-brown clay, not glazed.

576. Similar. Light brown clay.

577-580. Similar. Brown clay.

581. Bowl with spout. Reddish-brown clay. One handle missing.

582. Child's saving-bank, in form of money-chest with lock indicated. On the sides incised floral designs, on the lid a pig and the inscription FELIX. The slit has been enlarged to extract the money.

583. Ink-well. Red clay. On top the letter S scratched in.

584. Ink-well. Light brown clay, red glaze. On top three comic masks are pasted. Between the masks incised inscription DEMETRIVS (?).

585. Ink-well. Brown clay, brown lustrous glaze.

XLII. ROMAN PROVINCIAL

586. Pitcher from Damezy (Marne). Greyish white clay. Rosettes and dots. Saint-Rémy-en-Rollat fabric.

587. Jug. White clay.

588. Bowl from Cologne. Brown clay. On shoulder humps pressed out with the finger from the inside.

589. Urn. Red clay. On the body six impressions.
590. Urn from Cologne. Dark brown glaze. On the body
five impressions.
591. Bowl. Grey clay.

XLIII. EGYPTIAN

Roman and early Christian epochs

592. Amphora, pointed at bottom. From Achmin. Reddish
clay, white slip. Blue and red color. Fluted hori-
zontally, red and blue lines and dots.
593. Jar from Upper Egypt. Reddish clay, white slip.
Red and blue color. Bands of blue, white and red;
on the white bands are blue and red dots and blue
zigzag lines.
594. Pilgrim's flask. Made from a form. Black clay, lus-
trous surface. On either side rosette. Roman (?)
period.
595. Similar from Chios. Brown clay. On one side standing
bearded saint in relief with book in right hand. On
the other sitting bearded saint writing in a book.
Early Christian.

XLIV. LAMPS

(a) Greek, turned on potter's wheel, black glaze
A: Open on top, handle, one nozzle

596. From Tarentum. Reddish clay. Scratched on the
edge Archytas Phi.
597. From Tarentum. Scratched on the edge Aristipp(os).

B: Open on top, no handle, hole in middle for support

598. Reddish clay. One nozzle.
599. Brown clay. Two nozzles.

(b) *Italian, turned on potter's wheel, black glaze*
Third and second centuries B. C.

C: Similar to A, but with high foot

600. Light brown clay.

D: Small opening, ring-shaped handle

601. Brown clay, dull glaze. Incised inscription QVIS
EMET IS VENDICAT. Handle and nozzle
broken away.

(c) *Roman, made from a mould*

E: Rectangular nozzle, one handle

602. Two nozzles. Light brown (partly grey) clay. Not
glazed. Warrior and front part of horse. Two
holes for filling. Stamped on bottom NATO (?).

F: Angular volute-nozzle

603. Light brown clay, reddish glaze shading into brown.
Two boxers. No handle.
604. Light brown clay, reddish glaze. Sea-monster and two
dolphins. No handle. On bottom indistinct stamp.
605. Yellow clay, brown glaze. Gladiatorial combat, in-
scribed S(tantes) MIS(si), an undecided contest.
Below SABINVS AND POPILLIVS, the names of
the gladiators. No handle.
606. Presumably from Pompeii. Light brown clay, brown
glaze shading into black. Cupid playing on double-
flutes. Ring-shaped handle.
607. Light brown clay, lustrous brown glaze. Head of a
horse. No handle.
608. Red glaze. Five dolphins, referring to the seven
dolphins on the spina of the Circus or Hippodrome.
On bottom illegible stamp.

609. Red glaze. The centaur Nessus with Deianira on his shoulder.

610. Lustrous brown glaze. Cupid giving a lion to drink. A second Cupid plays with the lion's tail.

G: Circular volute-nozzle

611. From Rome. Yellow clay, red glaze shading into dark brown. Handle missing.

612. Light yellow clay, reddish glaze. Dwarf carrying two baskets. No handle.

613. Yellow clay, red glaze. Telephus and the hind.

614. From Cyprus. Light brown clay, unvarnished. Cupids playing with the armor of Hercules. Below indistinct inscription ADIVVATE SODALES.

615. Light yellow clay, brown glaze. Same subject. Above the same inscription.

616. Red glaze. Grape-vines growing in a crater. On bottom illegible stamp.

617. Brownish-yellow clay, brown glaze. Bust of Zeus on eagle, thunderbolt in its claws.

618. Red glaze. Cupid sitting on a chest; on the left a bearded herm. On bottom two letters A(?)Λ.

619. Red glaze. Juggler with monkey and dog (?). On bottom incised cross.

620. Red glaze. Hole for filling in the center. Rosette.

621. Reddish clay, red glaze. Similar decoration. On the shoulder stamped palmettes. On bottom plastic rings.

622. Brownish clay, red glaze. Dionysus and Ariadne on panther. Nozzle broken away; it may therefore belong to class F.

623. Brown clay, brown glaze. Man killing a pig. On bottom the letter D and retrograde the letters PRI. Nozzle broken away; it may therefore belong to class F.

624. Yellowish clay, reddish-brown glaze. Two Cupids playing with a sleeping lion. On bottom IIIIT. Nozzle missing; perhaps class F.

625. Grey clay, brown glaze. Triangular handle of a lamp. Two swans confronted, between them palmette. Probably Egypto-Roman fabric. It may belong to class F.

626. Grey clay, dark brown glaze. Similar handle. God of the Nile and goddess of Egypt. Egypto-Roman fabric. Belongs either here or to class F.

627. From Chios. Brown clay, black inside, red color almost entirely worn off. Youthful head in high relief, thirteen small holes.

628. Light brown clay with flakes of mica. Unglazed. Two nozzles. Mask of Medusa.

629. Yellow clay, reddish-brown glaze shading into dark brown. Two nozzles. On top concentric rings. On the triangular handle, acanthus leaves and palmette.

H: Similar nozzle with volute extending to the shoulder

630. Whitish-yellow clay, red glaze. Isis, rudder, crescent and star.

631. Reddish glaze. Gladiatorial combat; an Oplomachus attacking a Thrax who has fallen and is begging for mercy. Stamped in Greek letters *Gaiou*.

I: Circular nozzle

632. Light yellow clay, red glaze. Gladiatorial combat; a Retiarius down on one knee has thrown his net over the shoulder of a Secutor. In the field trident of Retiarius. Only the upper part of the lamp and part of the nozzle.

633. Yellowish clay, red glaze. Circles. The nozzle is more like class K.

634. Yellowish-grey and red clay mixed. Unvarnished. Bust of Serapis on eagle; moon and star.

685. Greyish-brown clay. On bottom stamp PONT HIL.
686. From Tarentum. Light brown clay. On the shoulder twigs and grapes. On the bottom stamped in Greek letters *Loukiou.*
687. Light brown clay. Central hole for filling. On shoulder rosettes, on bottom ivy-leaf in relief.
688. On high stand. Yellow clay, red glaze. The lamp itself is not decorated, but on the stand is a Cupid with cithara in right and plectrum in left hand.
689. Similar. Reddish-brown glaze. Leaf-shaped handle. On the stand Venus.
640. Rectangular with two nozzles at each corner and a ninth in front in the middle. Brownish-yellow glaze. Crescent-shaped handle.

J: Circular nozzle with two bands in relief on shoulder

641. Reddish-brown clay, unvarnished. Gladiatorial combat. A Secutor attacks a falling Retiarius. Greek inscription *Sposianou* occurs on top and on the bottom.
642. Brown clay. Cupid playing on syrinx, in his right hand a thyrsus, before him an altar. On bottom ΛΕ.
643. Reddish clay. Attributes of Apollo: tripod and snake, cithara and raven, crater on base. On bottom Greek inscription *Kl[audi]ou.*

K: Heart-shaped nozzle and decorated shoulder

644. Light yellow clay, colored red. Two bearded men; each holds a book-roll. On shoulder garlands.

L: With open spout

645. Red clay. No handle. On bottom is stamped OCTAVI, wreath below. Two projections, not pierced.
646. Similar. Reddish clay. On bottom is stamped PAT.
647. Similar. Brown clay. On bottom wreath. Three projections, not pierced.

M: Christian

648. Red clay. Monogram of Christ. Bearded heads of the twelve apostles. On bottom circles and four dots.

649. Red clay. Circles and triangles, star and quadrangle. On bottom circles.

650. Red clay. Lion, plaited pattern. Handle and nozzle broken away.

651. Similar to no. 649. Along the edge rosettes and ivy-leaves.

652. Red clay. Galloping horse.

653. Reddish clay. Cross. Three holes for filling.

654. Reddish clay. Quadrangular with seven holes for wicks. Goliath inscribed *Goulida* in Greek letters attacked by David, also inscribed.

N: With open receptacle and long open nozzle

655. Brownish clay, green enamel. Early Mediæval.

O: Imitating various objects

656. Dog. Reddish clay. Hole for filling in his back, hole for wick between his forepaws. Handle between neck and back.

657. Head of negro. Light brown clay, red glaze. Hole for filling in his head, hole for wick in his mouth.

658. From Chios. Caricatured head. Brown clay modelled in the style of terra-cotta figurines with white slip and red color. Hole for filling over the forehead, hole for wick in the chin. Handle missing.

659. Right hand. Dark red clay. Hole for wick in middle-finger. Handle missing.

660. Boat. Light brown clay, red glaze. On each side five nozzles. On the bottom three vine-leaves.

661. Pine-cone. Reddish clay. Hole for filling and handle on top. Hole for wick and open spout similar to class L. Three feet.

P: Miscellaneous

662. Caricature of bald-headed man, impossible position. From Tarentum. Light yellow clay, traces of black glaze. Greek fabric similar to class A.

663. From Tarentum. Light brown clay, reddish glaze shading into dark brown. On top head of negro in relief. Handle and nozzle broken away.

664. Yellow clay, reddish-brown lustrous glaze. On top elephant's head. Handle and nozzle broken away.

665. Brown clay, dark brown glaze. On top bird. Handle missing.

666. Greyish-brown clay, green enamel. On shoulder tendrils and bunches of grapes highly conventionalized.

667. From Tarentum. Greyish-white clay, unvarnished. On top bearded head in high relief, and traces of another head, perhaps Isis and Serapis.

668. Light brown clay. Hole for filling in center. Nozzle damaged.

Ring-shaped with many nozzles

669. Yellow clay, reddish-brown glaze. Floral designs. Arched handle. Below incised inscription ORGIAC (?).

670. Yellowish clay, red glaze. On each side a small lamp is fastened. On handle of large lamp a receptacle; outside four cocks with palms, stamped circles.

Heart-shaped

671. Yellowish clay, thin brownish glaze. Lozenge-shaped nozzle. Leaf-shaped handle.

672. From Tarentum. Light yellow clay, reddish-brown glaze. Handle of a lamp in form of horse's head.

673. Red glaze. Circular. In middle round hole surrounded by ten slits. Probably not a lamp.

Q: Mould

674. Light brown clay. Mould for upper part of lamp with lozenge-shaped nozzle. Central hole for filling. On shoulder egg and dart moulding. Palmette at juncture of nozzle.

R: Lanterns

675. Brown clay, unvarnished. Vertical handle, three feet. Body pierced with small holes.

676. From Makronisi near Eretria. Yellowish clay. The opening is in shape of a human mouth, above which are nose, eyes and eyebrows. The almost cylindrical body of the lantern is pierced with many other holes like those for the eyes. On top high handle ending in a ring. Greek fabric.

INDEX

Achilles, 109, 123; Nereid with shield of, 369; Nereid and Thetis with armor of, 352.

Admetus, legend of, 112.

Ajax, 109, 171.

Almond, vase in form of, 175, 176.

Altar, 142, 152, 166, 187, 217, 642.

Amazon, 129, 321, 325, 348; head of, 138, 139, 340.

Amazonomachy, 321, 348.

Amphitrite, 154.

Amymone, 154.

Annius, Sextus, potter from Arezzo, 521.

Aphrodite (Venus), 154, 211 (?), 328 (?), 639.

Apollo, 112 (?), 198, 548; attributes of, 643.

Apostles, bearded heads of twelve, 648.

Archytas, 596.

Ares, 328 (?).

Argus, death of, 117.

Ariadne, 622.

Aristippos, 597.

Artemis, 324 (?).

Astragalus, vase in form of, 456, 457.

Athena, 109, 135, 149, 196, 199, 211, 328; head of, 373; statue of, 171.

Athlete, 123, 143, 164, 234.

Bacchante, see Mænad.

Banquet, 130.

Barbarian, 170.

Biga driven by Demeter, 328; by Enyo (?), 328; by Nike, 328; by Pluto, 328.

Birds, 24, 33, 56, 59, 68, 70, 76, 79, 82, 89, 106, 124, 153, 180, 189, 212, 222, 276, 286, 529, 551, 643, 665.

Boar, 112.

Boat, 1; lamp in form of, 660.

Book, 595; book-roll, 644.

Boreas, 150.

Boxer, 234, 603.

Bride, 155.

Bull, 80, 105, 117, 157; head of, 351.

Caduceus (kerykeion), 112, 117, 135, 193, 328.

Canoleios, L., a Calenian potter, 328, 330.

Captive, 549.

Caricature of bald-headed man, lamp in form of, 662.

Caricatured head, lamp in form of, 658.

Cassandra inscribed *Katadra,* 171.

Castanets, see crotala.

Castus, potter from La Graufesenque, 540, 541.

Cat-like animal, 157.

Censorinus, potter from Lezoux, 548.

Centaur, 326, 609; with body ending in leaves, 510; with human forelegs, 220.

Centauromachy, 326.

Chrysantus, 563.

Cithara, 638, 643.

Cock, 511, 670.

Cocus, potter from La Grau-fesenque, 543.
Comitialis, potter from Rhein-zabern, 549.
Creeping child, 144.
Crescent, 630, 634.
Cross, on Christian lamp, 653.
Crotala (castanets), 121.
Cupid, see Eros.
Cycnus, 111.

Dancing men, 103, 123, 185; girl, 107, 121, 132.
David, 654.
Deer (see also fawn, hind), 79, 157 (?), 196, 232, 233, 361.
Deianira, rape of, 609.
Demeter, 328.
Demetrius (?), 584.
Demon, winged female, 126.
Dice, throwing, 109.
Dionysus, 128, 131, 134, 172, 198, 199, 324 (?), 511, 622; head of, 360, 493.
Distaff, 119.
Dog, 75, 76, 77, 78, 619 (?); lamp in form of, 656; vase in form of, 454.
Dolphin (see also fish), 198, 608; dolphins to indicate the ocean, 113, 604.
Double-flutes, 121, 130, 132, 165, 166, 185, 287, 510, 606.
Dwarf, 162, 612.

Eagle, 82 (?), 105, 111, 617, 634; head of, 499.
Ear-rings, 70, 126.
Egypt, goddess of, 626.
Elephant, head of, 664.
Ennius, 522.
Enyo, 328 (?).

Eppillius, potter from Lezoux, 551.
Eros (Cupid), 132, 153, 198, 200, 205, 263, 266, 269, 270, 272, 343, 510, 548, 606, 610, 614, 615, 618, 624, 638, 642.

Fawn, 263.
Felix, 582.
Female head, vase in form of, 173.
Fish (see also dolphin), 33, 198, 251, 345-347; to indicate the ocean, 113, 233.
Floating figures, 359.
Flute-player, Centaur as, 510; Eros as, 132, 606; female as, 121, 130; man as, 185; youth as, 166.
Fox, 128.

Gaios, 631.
Giant attacked by Dionysus, 199; with serpent-shaped legs attacked by Athena, 199.
Gladiatorial combat, 605, 631, 632, 641.
Gladiators, names of, Popillius and Sabinus, 605.
Goat, 79, 102.
Goliath, inscribed Goulida, 654.
Goose, 56, 329.
Gorgo (Medusa), head of, 198, 220, 551; mask of, 488, 628.
Griffin, 170, 220, 321; head of, 350; protome of, 138, 223.

Halteres, 164.
Hand, lamp in form of, 659.
Hare (rabbit), 75, 246 (?), 329, 343.
Hedgehog, vase in form of, 62, 63.

Helmeted head, vase in form
of, 69.
Hera, 117 (?).
Heracles, 111, 129, 140, 199, 217,
233 (?); armor of, 614, 615;
as child strangling the snakes,
870.
Herm, 548, 618.
Hermes, 112, 117, 135, 328.
Hesperides, Heracles in garden
of, 140.
Hind (see also deer), 613.
Hippocamp, 113, 369; vase in
form of, 352.
Hood, 70, 119, 138, 151.
Horse, 59, 92, 116, 602, 659;
head of, 138, 139, 607, 672.
Horseback, Troilus on, 123;
youths on, 108, 110, 325.
House indicated by double-door
between two columns, 155.

In-door scene, 148, 167.
Ink-well, 583, 584, 585.
Inscribed vases, Etruscan, 222,
481 (?), 520; Greek, 134, 137,
154, 155, 165, 166, 167, 169,
171, 201, 213, 397, 423, 429,
440 (?), 443, 596, 597, 631,
636, 641, 642, 643, 648, 654;
Latin, 328, 330, 521, 522, 524,
525, 527, 528, 533, 540, 541,
542, 543, 544, 545, 546, 547,
548, 549, 551, 563, 582, 583,
584, 601, 602, 604, 605, 608,
614, 615, 616, 618, 623, 624,
635, 645, 646, 669.
Io transformed into a cow, 117.
Iris pursued by Silenus, 140.
Isis, 630, 667 (?).

Juggler, 619.

Kale (inscription), 155; kalos,
137, 169; ho pais kalos, 165,
166.
Kerykeion, see caduceus.
Klaudios, 643.

Lion, 80, 82, 111, 112, 232, 321,
361, 549, 610, 624, 650; head
of, 474; Nemean, 199; pro-
tome of winged, 329; skin of,
111, 129, 367.
Lobster-claw, vase in form of,
177.
Loin-cloth worn by athletes,
234.
Loukios, 636.
Lyre, 134, 185, 198.

Maccarius, 544.
Mænad (Bacchante), 133, 134,
198.
Masks, 200, 285, 288, 289, 304,
318, 512, 548; comic, 501, 506,
584; of Medusa, 488; of Pan,
287; of Silenus, 364, 365, 368.
Medusa, see Gorgo.
Mirror, 167, 271.
Monkey, 619.
Monogram of Christ, 648.
Monster, half man and half fish
(halios geron ?), 233.
Moon, see crescent.
Mule, 128; head of, 506.
Muranus, 546.
Mussel-shells, vase in form of,
174, 195.

Necklace, 70.
Negro, head of, 358, 663; lamp
in form of head of, 657; vase
in form of crouching, 455.
Nereid, 352, 369.
Nessus carrying Deianira, 609.

Nike, 198, 199, 266, 328.
Nile, god of the, 626.
Nymphs, 217.

Octavius, 645.
Omphale, head of, with lion's skin, 367.
Oplomachus, 631.
Ostrich-egg, vase in form of, 1, 2.
Owl, 163, 323, 338, 339.
Ox, vase in form of, 51.

Palms, 670.
Pan, 320, 324; mask of, 287.
Panther, 102, 105, 106, 111, 112, 188, 551; Ariadne and Dionysus on, 622; Dionysus on, 199; skin of, 455.
Perseus, 551.
Pig, 582, 623.
Pilgrim's flask, 594, 595.
Pine-cone, lamp in form of, 661.
Plectrum, 638.
Pluto, 328.
Polyxena, 123.
Pomegranate, vase in form of, 61.
Pontus, 542.
Popillius, a gladiator, 605.
Poseidon, 113, 145, 154.
Potters, names of, Annius, Sextus, 521; L. Canoleios, 328, 330; Castus, 540, 541; Censorinus, 548; Cocus, 543; Comitialis, 549; Ennius, 522; Eppillius, 551; Gaios, 631; Klaudios, 643; Loukios, 636; Maccarius, 544; Muranus, 546; Octavius, 645; Pontus, 542; Rasinius, 527; Sposianos, 641; Villius, 524.
Proserpina, rape of, 328.

Rabbit, see hare.
Ram, 158, 200, 217; head of, 200, 224.
Rasinius, 527.
Raven, 643.
Retiarius, 632, 641.
Rhytum held by dancer, 103.
Rudder, 630.

Sabinus, a gladiator, 605.
Saint, on pilgrim's flask, 595; saints (twelve apostles) on lamp, 648.
Satyr, 198, 217, 548; bust of winged, 327 (?).
Saving-bank, in form of money-chest, 582.
Sea-horse, see hippocamp.
Sea-monster, in form of bull, 551; with two fish-tails, 604.
Secutor, 632, 641.
Serapis, bust of, 634, 667 (?).
Shields, miniature, 182, 183.
Silenus, 131, 133, 140, 158, 169, 172, 267, 325; inscribed Marsyas, 134; mask of, 114, 115, 364, 365, 368.
Siren, 89, 104, 105, 106, 107, 108, 142, 235; vase in form of, 93.
Snake, 315, 370, 489, 643.
Sphinx, 105, 106, 146, 321.
Spindle, 119.
Sposianos, 641.
Star, 59, 183, 245, 630, 634, 649.
Strigil, 123.
Swan, 89, 261, 269, 277, 287, 625; head of, 317.
Swastika, 58, 60, 193, 194, 245.
Symposium, 165.
Syrinx, 642.

Telephus, 613.
Temple, 187.

Theseus conversing with Poseidon, 145.
Thetis on hippocamp, 352.
Thrax, 631.
Thunderbolt, 617.
Thyrsus, 131, 133, 134, 324, 493; as attribute of Eros, 642.
Tomb, mourners at, 151, 168, 336, 342 (?).
Torch, 131, 134.
Tortoise, vase in form of, 120.
Trainer of athletes, 137.
Trap, bird in, 286.
Trident, 113, 145; of retiarius, 632.
Tripod, 643.
Troilus, 123.
Trophy, 199.

Tyche inscription, 213.
Tympanum, 132, 133.

Umpire, 234.

Venus, see Aphrodite.
Victory, goddess of, see Nike.
Villius, potter from Arezzo, 524.

Warriors, 88, 107, 108, 109, 199, 234, 321, 326, 348, 602.
Water indicated by fish, 113, 233; indicated by wavy line, 233.
Wine-skin, 455.
Wolf (?), 112, 233.

Zeus, bust of, on eagle, 617.

CPSIA information can be obtained
at www.ICGtesting.com
Printed in the USA
BVHW040543281118
534121BV00016B/89/P

9 781164 828617